T0150604

BENJAMIN WEST
AND THE DEATH OF THE STAG

THE STORY BEHIND THE PAINTING
AND ITS CONSERVATION

SUPPORTED BY

JERWOOD
CHARITABLE FOUNDATION

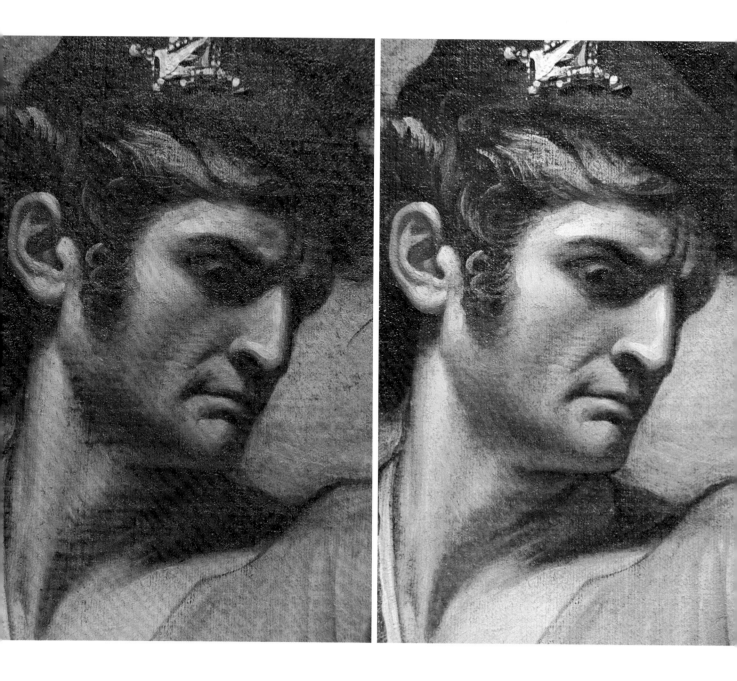

TIMOTHY CLIFFORD · MICHAEL GALLAGHER · HELEN SMAILES
EDITED BY DUNCAN THOMSON

BENJAMIN WEST
AND THE DEATH OF THE STAG

THE STORY BEHIND THE PAINTING
AND ITS CONSERVATION

NATIONAL GALLERIES OF SCOTLAND
EDINBURGH · 2009

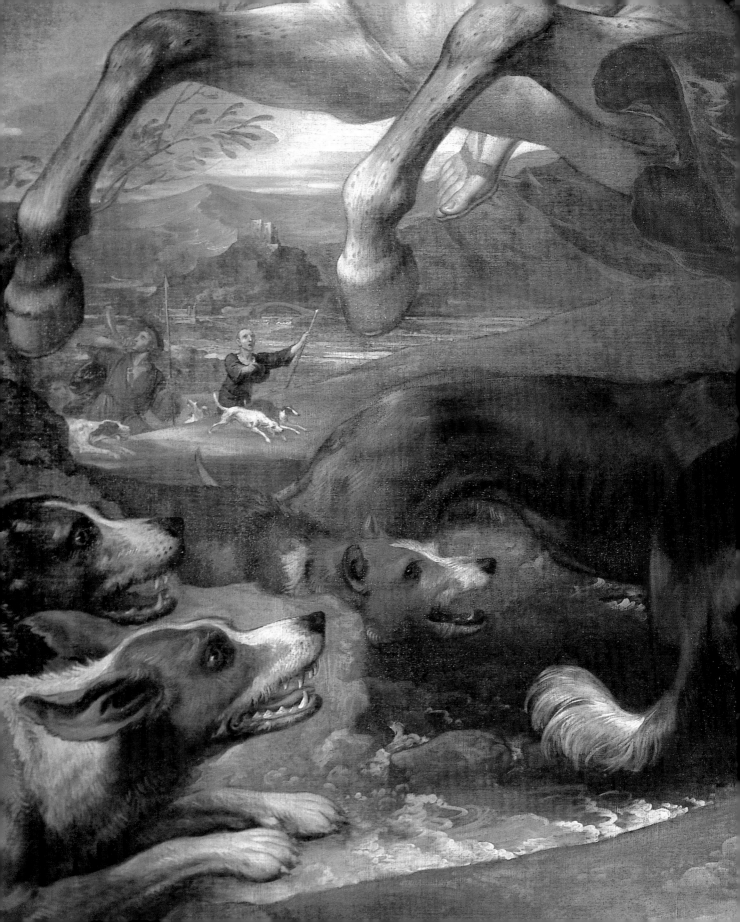

Benjamin West's *Alexander III of Scotland Rescued from the Fury of a Stag by the Intrepidity of Colin Fitzgerald (The Death of the Stag)*, a tour de force of pictorial theatre and his unique Scottish masterpiece, has been the focus of high drama for over two centuries. West's own career was also quite extraordinary. An expatriate Pennsylvanian portrait and history painter, he was the first American to influence artistic trends in Britain and Europe from a position of international authority. Elected a founder member of the Royal Academy of Arts five years after his arrival in London in 1763, he was to succeed Sir Joshua Reynolds as president in 1792 and sustained a reputation of quasi-mythical proportions into the second decade of the nineteenth century. For Francis Humberston Mackenzie, the last hereditary chieftain of the Seaforth line of Clan Mackenzie, West devised a phenomenal piece of dynastic propaganda on the scale of a royal or state commission and at a price equivalent to West's annual fee as official history painter to George III.

West's *The Death of the Stag*, a skilfully stage-managed and politically-driven celebration of the preservation of the monarchy by the legendary ancestor of the Clan Mackenzie, must have been the sensation of the Royal Academy exhibition of 1786. This gigantic canvas, first had to be manoeuvred up Sir William Chambers's elegant but notoriously steep and spiralling staircase into the Great Room of Somerset House on the Strand – presumably having been removed from its stretcher and rolled up – and then re-assembled on site. Once installed in the Great Room, where the most important paintings of the annual exhibition were displayed, it would have dominated an entire wall. There, as evidently anticipated by the artist and his Scottish patron, it was noticed by George III, West's most prestigious employer and patron of the academy.

High drama also attended the painting's eventual arrival in Scotland in 1822, thirty-six years after it was first exhibited. Rolled up again for the long sea voyage from London to the north-east of Scotland, *The Death of the Stag* risked exposure to high winds and salt water and the damage suffered by other Mackenzie family pictures on the same vessel. Once more, the painting had to be re-stretched on site, this time at the Mackenzie seat of Brahan Castle, Dingwall. Thereafter, until Brahan Castle was demolished in 1952, the drama subsided.

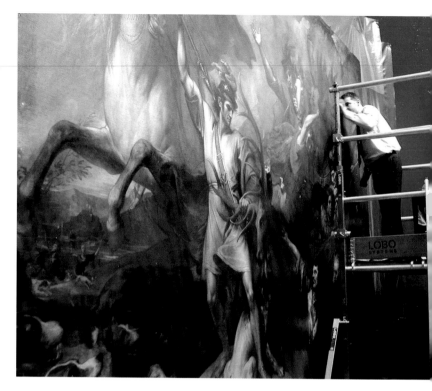

1 | *Conservation Live:* the vast size of West's painting meant that conservation work was carried out in situ in the National Gallery of Scotland under the public's gaze.

2 | The project was led by Michael Gallagher, then Keeper of Conservation at the National Galleries of Scotland, and now Sherman Fairchild Conservator in charge of the Department of Painting Conservation at the Metropolitan Museum of Art in New York.

6 While the painting remained in family possession, it was entrusted to the care of Fortrose and Rosemarkie Town Council and its successor, Ross and Cromarty District Council, and was hung in Fortrose Town Hall on the Black Isle. But in 1986, two hundred years after its launch at the Royal Academy, the painting was consigned to auction at Sotheby's in London by representatives of the family. Press coverage of the ensuing high drama was intensive.

At just over £550,000 the hammer price created a record for West's work on the open market. The purchaser would eventually be revealed as the National Gallery of Art in Washington – a measure of the exceptional status and stature of the painting. In the meantime, just two years into his distinguished directorate of the National Galleries of Scotland, Timothy Clifford and his curatorial team had already recognised the immense significance of the West in the context of British history painting and were determined to try to secure for Scotland the artist's only Scottish history picture. Within a day of the London auction, there was talk of an export licence review and a six month deferral in order to allow British public galleries the chance to match the auction price. Led by Timothy Clifford, the campaign achieved a resounding success in 1987 when the work was purchased for the National Gallery of Scotland with major grant aid from the National Heritage Memorial Fund, the William Leng Bequest of The Art Fund and contributions from Ross and Cromarty District Council and Dennis F. Ward.

The high drama associated with the painting from 1786 resumed spectacularly in 2004. During the penultimate year of his directorate, Timothy Clifford initiated one of the most audacious and ambitious exercises in remedial conservation ever undertaken by the National Galleries of Scotland. Michael Gallagher, then Keeper of Conservation and now Sherman Fairchild Conservator in charge of the Department of Painting Conservation at the Metropolitan Museum of Art in New York, led the project and single-handedly undertook the cleaning and restoration of the work [2]. From the perspective of the twenty-first century, the historical expedient of removing the enormous canvas from its wooden stretcher and rolling it up for transport elsewhere was considered far too hazardous. Conversely, the prospect of having to construct a

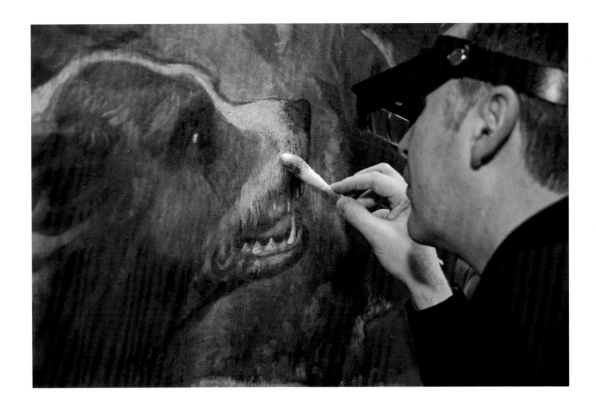

FOLLOWING PAGES

3 | Benjamin West
(1738–1820)
*Alexander III of Scotland
Rescued from the Fury of a
Stag by the Intrepidity of
Colin Fitzgerald*
(*The Death of the Stag*), 1786,
after restoration

National Gallery of Scotland,
Edinburgh (NG 2448)
Purchased with the assistance of
the National Heritage Memorial
Fund, The Art Fund (William
Leng Bequest), Ross and
Cromarty District Council and
Dennis F. Ward, 1987

temporary studio on site at the National Gallery offered a whole range of exciting educational possibilities from informal lectures and audio-visual presentations in proximity to the work in progress to an exploratory display about the commissioning and history of the painting and an unrivalled opportunity for the visiting public to witness the gradual transformation of one of the Gallery's most iconic paintings.

The project, *Conservation Live*, ran from February 2004 to the close of the year and generated great interest across a wide spectrum of gallery audiences [1]. In order to deliver the full potential of the project, the National Galleries approached the Jerwood Charitable Foundation which generously agreed to underwrite this extraordinary venture. Established during the 1970s as the Jerwood Foundation, it came to the fore in the later 1990s as one of the leading UK-based charitable supporters of cultural projects, encompassing both the visual and the performing arts and promoting strong and lasting working partnerships with many of its beneficiaries.

As the culmination of the project, staff at the Galleries organised a conference on West on 25 February 2005 which was chaired by Professor Brian Allen, Director of the Paul Mellon Centre for Studies in British Art in London. Headed by the international West scholar, Emeritus Professor Allen Staley of Columbia University in the United States, the speakers included Christopher Lloyd, then Surveyor of the Queen's Pictures, on West and his serial commissions for George III; Martin Postle, then Chief Curator of the historic British collections at Tate, on West's influential contribution to the development of eighteenth-and early nineteenth-century British history painting; and Hugh Cheape, then Senior Specialist in Highland material culture at the National Museums Scotland, on the public image of the Highlands and Highland culture after the Jacobite Risings. Of the other conference papers given by members of the Galleries' own staff, those by Timothy Clifford, Michael Gallagher and Helen Smailes, form the basis of this publication.

JOHN LEIGHTON
Director-General, National Galleries of Scotland

HELEN SMAILES
Senior Curator of British Art

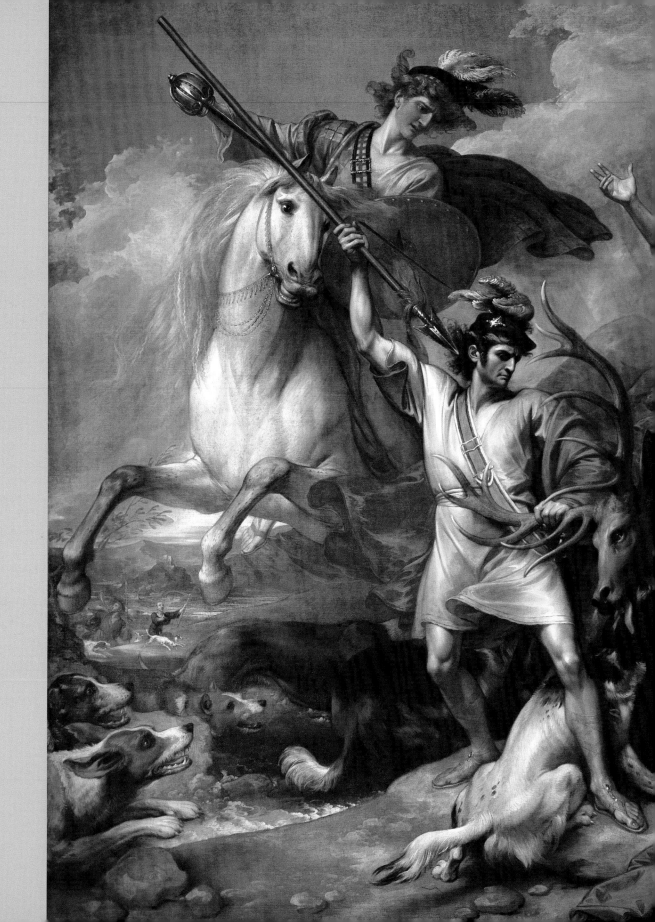

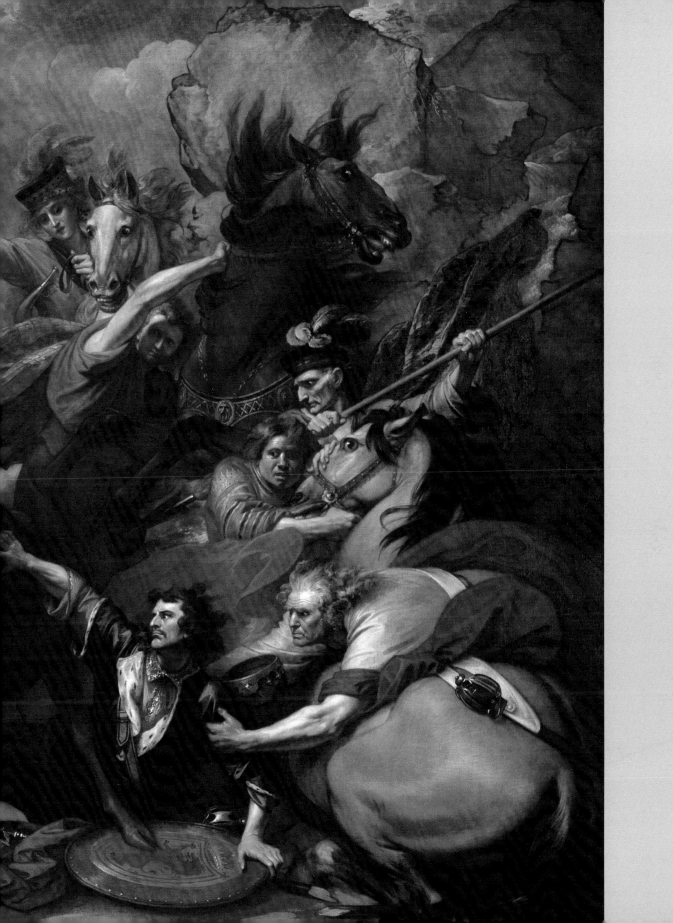

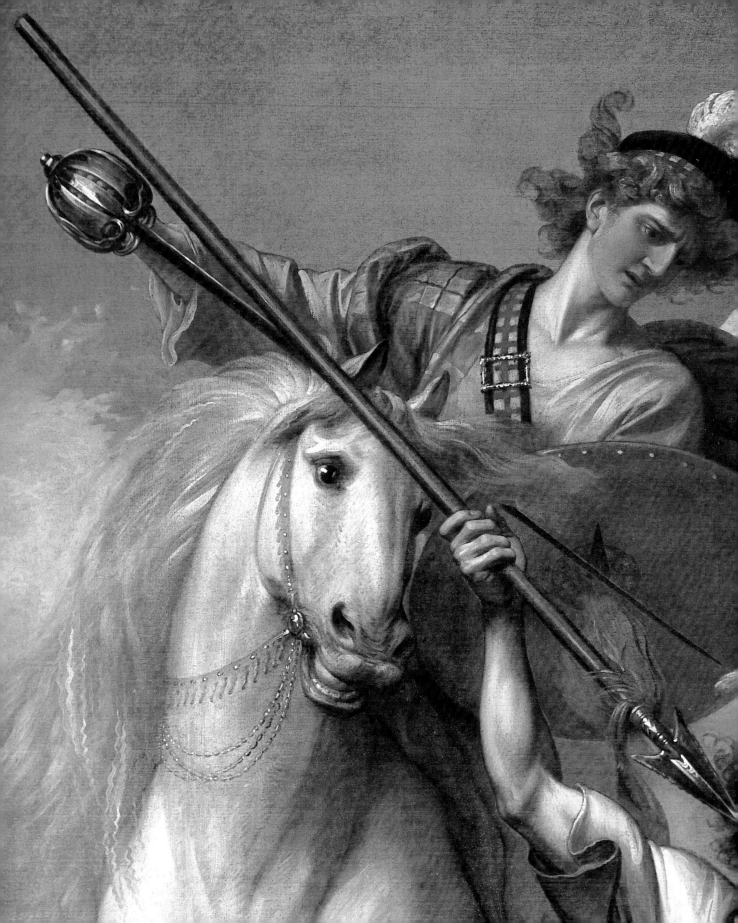

A Painting by Benjamin West for the Chief of the Clan Mackenzie

Timothy Clifford and Helen Smailes

'Men, horses and dogs in action; a stag pressed hard, and the life of a king at stake – a romantic country too, what a field for painting to effect magic in.' Such was the reaction of one London critic to Benjamin West's vast painting, *Alexander III, King of Scotland, Rescued from the Fury of a Stag by the Intrepidity of Colin Fitzgerald, Ancestor of the Present Mackenzie Family,* when it was shown at the Royal Academy of Arts in London in 1786, shortly after it had been completed. This exceptionally long title was the one given to the painting in the catalogue of the exhibition, and its reference to the 'present Mackenzie family' had, as will be seen, a particular significance. The painting, also notable for its size as well as the romantic story it told – it measures 3.685 metres in height by 5.225 metres in width (or 12 × 17 feet) – was widely acclaimed by the critics, and even the king, George III, patron of the academy, was moved to remark that although many painters and sculptors had depicted horses with a 'noble and pictorial air', West had excelled them in understanding their actions.

The painting had an impact in Edinburgh as well as London. A writer in the *Edinburgh Evening Courant*, reviewing the Royal Academy exhibition, praised West and his painting 'in which the King of Scotland is preserved by the timely interposition of a Highland Chief, who rescues his Majesty from the fury of an enraged stag'. The reference to 'a Highland Chief' suggests an awareness of the significance of the extended title, for the writer goes on to record that the painting had been commissioned by a present-day Highland chieftain, Francis Humberston Mackenzie (later Lord Seaforth) who claimed lineal descent from Colin Fitzgerald. In the general critical acclaim which surrounded the painting, Mackenzie had been commended for his patronage of British history painting – the depiction of scenes from ancient history being seen generally as a higher form of art than the portraits of themselves, which British patrons tended to prefer. Mackenzie was determined to be recognised as a major patron – the rumoured price of the painting was 1,000 guineas (in fact, the cost was 800 guineas) – but it is likely that the Edinburgh critic had sensed that behind this piece of national epic lay a more personal concern, Mackenzie's need to promote the rehabilitation of his family's reputation which had been damaged by involvement in the Jacobite Rebellions of 1715 and 1719, leading to the loss of their hundred-year-old earldom of Seaforth.

What is the story that the painting tells, and what is its origin? Of the pioneering histories of Scotland that appeared in the second half of the eighteenth century and became a source for history painters, only that by Lord Hailes considered the reign of Alexander III in any depth and it makes no mention of the rescue of the king by Colin Fitzgerald. The story, or legend, seems to have survived in oral tradition until it was given written form by the lawyer and statesman, Sir George Mackenzie, in his *Genealogie of the Mackenzies* of 1669. Sir George, who was both cousin and brother-in-law of the 3rd Earl of Seaforth, as well as great-grandson of the sixteenth-century chieftain of Clan Mackenzie, Colin Mackenzie of Kintail, served as Secretary of State under Queen Anne and was created Earl of Cromartie in 1703. In his quest for family origins, a concern of many at that time, Sir George sought to replace a Gaelic pedigree by an Anglo-Irish one deriving from the Fitzgeralds. In some ways this was a game plan similar to that pursued by his kinsman, Francis Humberston Mackenzie, in the 1780s when he commissioned West's painting.

The story, which the painting visualises in great detail, concerns Colin Fitzgerald, a son of the Earl of Desmond, who was driven from his native Ireland and was given shelter by Alexander III, King of Scots, who had succeeded to the Scottish throne in 1249. During a royal hunt near Kincardine, the king was attacked by a stag and escaped death only by the timely intervention of Fitzgerald who grappled with the animal before killing it. This became the principal action of the painting, which shows the king slipped from his mount in the foreground, his right arm raised in consternation against the neck of the stag while the upright figure of Fitzgerald grasps the stag by its antlers and pulls it to its knees, at the same time raising his spear in his right hand to deliver the death-blow. For this act of salvation, the king granted Colin Fitzgerald the lands of Kintail in Ross-shire, which included the ancient castle of Eilean Donan on Loch Duich. Although the royal hunt had taken place in a different part of Scotland, the castle in the background of the painting is likely to be an attempt to represent

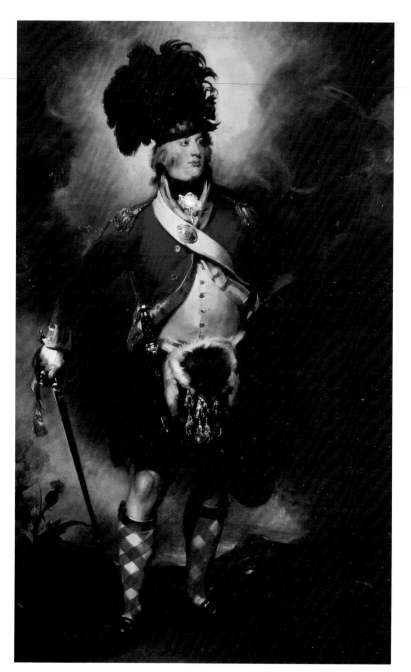

Eilean Donan, the original stronghold of the Clan Mackenzie. West had never seen Scotland, but his quite convincing Highland view may well have been based on drawings provided by others. At any rate, this is the tale of origins and loyalty to the crown which Mackenzie must have discussed in great detail with his chosen artist when he conceived the painting as part of his purpose to revive his family's social and political fortunes.

4 | William Dyce (1806–1864) copy after Sir Thomas Lawrence *Francis Humberston Mackenzie, Lord Seaforth, who Raised the 78th Highlanders in 1793*

The Highlanders' Museum, Fort Geroge, Ardersier, Inverness

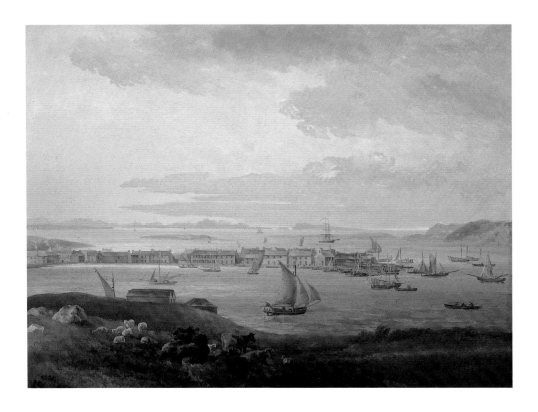

FRANCIS HUMBERSTON MACKENZIE, LORD SEAFORTH

Francis Humberston Mackenzie (1754–1815) was the son of Major William Mackenzie (himself son of a younger brother of the 5th Earl of Seaforth) and a Lincolnshire heiress, Mary Humberston [4]. As an Eton schoolboy he contracted scarlet fever and became profoundly deaf – a lifelong disability which also impaired his speech. It was a disability, however, which did not prevent him playing a major role in society – as parliamentarian, soldier and patron of the arts. From 1784 to 1790, and again in 1794, he sat in parliament for Ross-shire. In 1800 he was appointed governor of Barbados, where he dealt with the slaves on the plantations in a way that could be described as liberal for those times. Always interested in the arts and sciences, he collected valuable information on the plants of the West Indies and famously lent the young painter Thomas Lawrence £1,000 at the beginning of his meteoric career.

Mackenzie's ancestors, supposedly stemming from Colin Fitzgerald, had continued to be loyal supporters of the Scottish royal line, and Colin Mackenzie of Kintail was created 1st Earl of Seaforth by James VI & I in 1623. It was he who founded the family seat at Brahan, near Dingwall. It was the recovery of this title, lost in 1716, that would motivate later members of the family, and particularly Humberston Mackenzie.

The family's troubles began in the late seventeenth century with Kenneth Mackenzie, the 4th Earl of Seaforth, who followed the Catholic James VII & II into exile at the time of the Glorious Revolution. Although captured in 1690 and initially tried for high treason, he was allowed to retire to France where he died in 1701.

His son William succeeded him as 5th Earl of Seaforth, but rashly confirmed his support of the Jacobite cause. He appeared at Braemar in 1715 with 3,000 men and was involved in the battle of Sheriffmuir. As a result, he was attainted the following year, a process which meant the loss of his titles and forfeiture of his estates. This did not, however, discourage him from joining the rising of 1719, which culminated in the disaster at Glenshiel, where he was gravely wounded. As a result, the Hanoverians, in an act that was no doubt partly symbolic, reduced the castle of Eilean Donan to ruins.

13

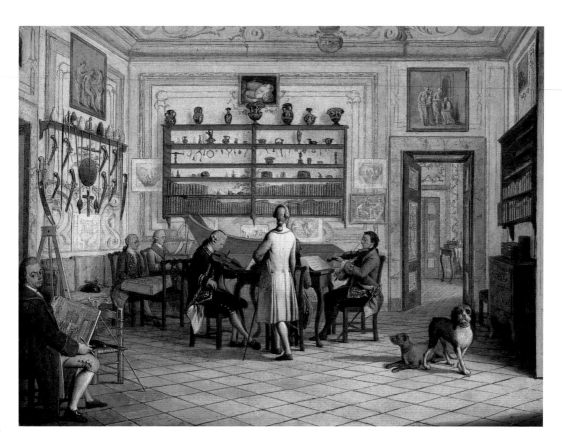

6 | Pietro Fabris
(fl.1768–1778)
*Kenneth Mackenzie,
Lord Fortrose at Home in
Naples: Concert Party*, 1771

Scottish National Portrait
Gallery, Edinburgh (PG 2611)
Purchased with the assistance of
The Art Fund, 1984

14

The long trek back to respectability began remarkably quickly; for in 1726 William was discharged from the personal penalties imposed on him and he was able to buy back some of the Seaforth lands in 1730. He died on his estate on the Isle of Lewis in 1740. Despite the attainder, his son Kenneth styled himself Lord Fortrose, the family's courtesy title, and went on to be a zealous supporter of George II during the final Jacobite Rebellion of 1745. This support paid a major dividend in 1766 when his son and successor, also Kenneth Mackenzie, was created Viscount Fortrose and could thus legitimately refer to himself as Lord Fortrose. More was to follow, although not quite the final accolade. In 1771, as antiquarian and connoisseur of the arts, he had himself depicted by Pietro Fabris in two highly descriptive paintings that show him in his Neapolitan villa in the company of the British ambassador, Sir William Hamilton, along with the Mozarts, father and son, other musicians and a group of young gentlemen practising fencing [6, 7]. In that same year, an *annus mirabilis* in retrospect, he offered to raise

a regiment of Highlanders, the 78th Foot (later to become famous, after amalgating with other regiments, as the Seaforth Highlanders). But this offer was not accepted until 1778. As the military requirements of European wars and Empire gathered pace, the disabilities the Highlanders had suffered after the Jacobite rebellions were now being rapidly reversed, so much so that they came to be seen as romantic and noble, and very British. There is little doubt that this perception is at least an underlying element in the painting that Humberston Mackenzie would commission in a few years time. What is certain is that Fortrose was rewarded in the same year with the longed-for earldom of Seaforth – though, like his viscountcy, it was in the peerage of Ireland and consequently did not carry a seat in the House of Lords.

Lord Seaforth would enjoy this honour for only ten years, dying without a direct male heir in 1781, so that the title was once again lost. In the meantime his extravagant lifestyle had led to the sale of his estates (for the enormous sum of £100,000) to his second cousin Thomas

7 | Pietro Fabris
(fl.1768–1778)
Kenneth Mackenzie,
Lord Fortrose at Home in
Naples: Fencing Scene, 1771

Scottish National Portrait
Gallery, Edinburgh (PG 2610)
Purchased with the assistance of
The Art Fund, 1984

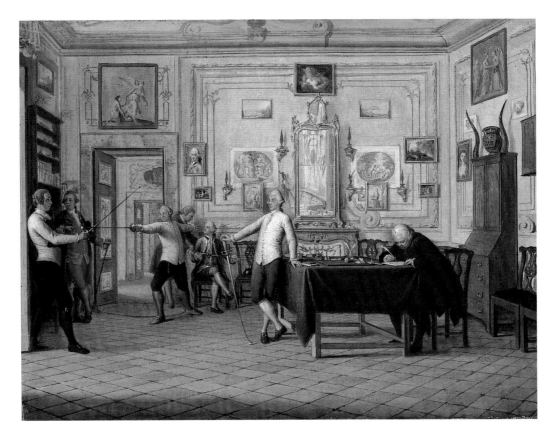

15

Frederick Mackenzie Humberston, son of the
Lincolnshire heiress, Mary Humberston, whose
name he had taken. This cousin was a descendant
of the younger brother of the attainted 5th Earl of
Seaforth, Major William Mackenzie, and he now
inherited the chieftainship of Clan Mackenzie.
He too did not enjoy that particular honour for
long, dying on active service in India two years
later. The clan chieftainship was now taken up by
his younger brother Francis, who had retained the
family name of Mackenzie. Shortly thereafter he
went on to conceive the purpose and content of
Benjamin West's enormous canvas.

This was not to be the only example of
Francis Humberston Mackenzie's conspicuous
expenditure. He continued to patronise other
artists, particularly Thomas Lawrence in the late
1790s, and like his brother he raised a Highland
regiment, the Ross-shire Buffs; he improved the
harbour at Stornoway [5] and supported other
local industries on the Mackenzie lands on the
Isle of Lewis, and engaged in the modernisation
of his principal Highland seat, Brahan Castle,
for which setting West's painting was no doubt

intended. In 1797, for his services in the realm of
public affairs, he was rewarded with a peerage
of Great Britain, but this was a barony, the fifth
and lowest level of the peerage, rather than the
hoped-for earldom. Whatever might have been
his disappointment, Humberston Mackenzie the
chief, or Caberfeidh, of Clan Mackenzie, could
once again assume the name Lord Seaforth.

He died in Edinburgh in 1815, the year of
Waterloo. He had married Mary Proby, daughter
of the Dean of Lichfield in 1782, and they had
four sons and six daughters (one of whom,
Frances, was briefly notorious as the fiancée of the
famous Danish sculptor, Bertel Thorvaldsen). All
four sons died before him and without heirs, so
that Seaforth's title became extinct. (The chief-
tainship of Clan Mackenzie would later devolve
on the junior branch of the family, the earls of
Cromartie, by whom it is still held.) It was noted
at the time of Seaforth's death that it had fulfilled
the prophecy of the seventeenth-century Brahan
Seer, Coinneach Odhar (Kenneth Mackenzie),
that the house of Seaforth would end with the
death of a deaf and dumb Caberfeidh.

Benjamin West, whom Humberston Mackenzie chose to paint his family's founding legend, had been born in Springfield, Pennsylvania, in 1738 [8]. Although probably not a Quaker, he was brought up in a Quaker community. West having shown early talent as a painter, two prominent citizens of Chester County, Provost Smith and Chief Justice Allen, agreed to support him in pursuit of his studies in Italy. He sailed from Philadelphia in the spring of 1760 and arrived in Livorno (called Leghorn by the British) three months later. He then visited the principal cities – Rome, Florence, Parma, Genoa, Venice and Turin.

In Rome he became acquainted with the most famous resident Scottish painter, Gavin Hamilton, and Anton Raphael Mengs from Dresden. These painters were the pioneers of what has become known as neoclassicism, where subjects drawn from classical history were treated in an idealised manner, where, nevertheless, care was taken to be 'archaeologically' correct in the depiction of details. West was a major proponent of this style and brought it to England, where he set up initially as a portrait painter in 1763.

While in Venice, West made another important contact in Richard Dalton, the librarian of George III, who was in Italy amassing old master drawings for the king. No doubt West's close friendship with Dalton played a part in the extensive royal patronage that West would come to enjoy. It was, however, one of his earliest and most ambitious classical subjects, *Agrippina Landing at Brundisium with the Ashes of Germanicus*, which played a crucial role in that patronage. Painted for Robert Hay Drummond, Archbishop of York, the picture is notable for an architectural background that is quoted from the architect Robert Adam's *Ruins of the Palace of the Emperor Diocletian, at Spalatro, in Dalmatia*, published only a few years earlier. Drummond showed the painting to George III, who admired it so much that he commissioned a similar work, *The Departure of Regulus from Rome*, which was shown at the Royal Academy's inaugural exhibition in 1769. Thereafter, West would produce some sixty history paintings for the king.

West, in fact, established himself surprisingly

16

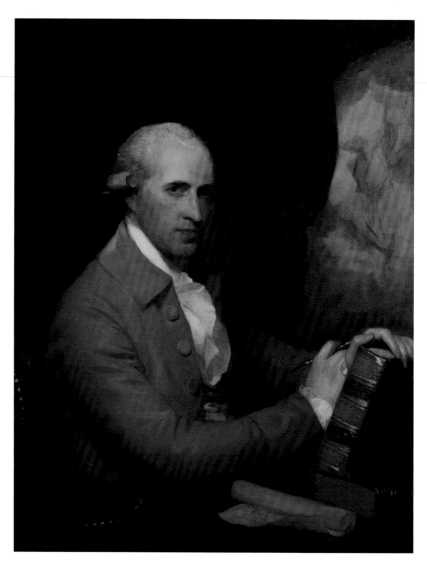

quickly as a central figure in the London art establishment. He was soon closely associated with the Society of Arts and became a founder member of the Royal Academy. In 1770 he created a certain degree of controversy by clothing the subjects in his *The Death of General Wolfe* in contemporary costume, rather than the classical dress which viewers expected [9]. It seemed a shocking innovation, but soon became standard practice and an important turning point in the history of European painting. Two years later, he had been appointed 'Historical Painter to the King', a relationship with the monarch that culminated in his succession to Dalton as 'Surveyor of the King's Pictures' in 1791. The following year he succeeded Sir Joshua Reynolds

8 | Gilbert Stuart
(1755–1828)
Benjamin West, c.1785
National Portrait Gallery,
London (NPG 349)

9 | Benjamin West
*The Death of General Wolfe
(1727–1759)*, 1770

Transfer from the Canadian
War Memorials, 1921 (Gift of
the 2nd Duke of Westminster,
England, 1918)
National Gallery of Canada

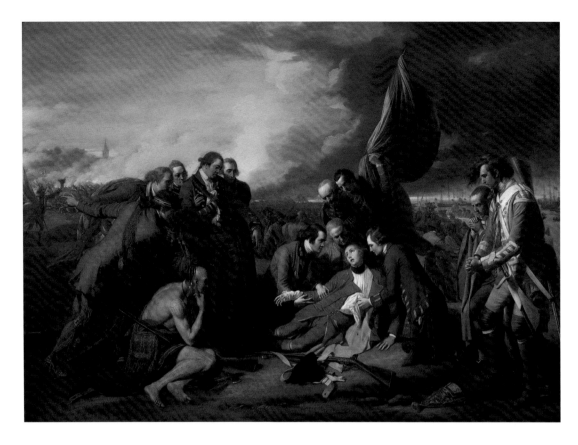

as President of the Royal Academy. In the years
that followed he gained enormous international
prestige and by the time of his death in 1820 he
was held in considerable awe.

It is possible that Humberston Mackenzie
and his chosen artist met in the context of the
Society of Dilettanti, which had campaigned
for the formation of an academy of the arts and
sponsored archaeological expeditions which made
an important contribution to the neoclassical
movement. In or about 1777, Reynolds painted
a group portrait of members celebrating their
function as arbiters of taste. Prominent among
them is Mackenzie's kinsman, Lord Seaforth,
classical gem in one hand and bottle of claret in
the other. It is a context redolent of what West
and Mackenzie stood for.

What is certain is that Humberston Mac-
kenzie and West must have held long and detailed
discussions in London about the content of the
painting. Many drawings and preparatory studies
were produced – there are, for example, detailed
preliminary compositional drawings in the
National Gallery of Scotland and at Petworth.

A carefully worked-up drawing lacks some of the
features of the final painting: the crown, fallen
against the flank of the stag has a different form;
the stag has an impossible nineteen points rather
than the 'royal' twelve of the final painting; and
the targe was not included in the foreground. The
targe in the painting, trodden on by the gasping
stag and grasped by the king, bears a carefully
depicted engrailed lion of Scotland – a feature,
like the basket-hilted Highland broadsword
raised by the rider on the left, no doubt requested
by Mackenzie.

Conceived on a scale that rivalled state or
royal commissions, the artistic foundations of
the painting are both neoclassical and romantic.
West's intimate knowledge of antique Roman
sculpture, particularly the reliefs on the so-called
Meleager sarcophagi, may have dictated the
shallow, frieze-like form of the composition,
while individual figures bear a debt to specific
pieces of antique sculpture: the prostrate figure
of the king is close to *The Dying Gaul* [10]; the
figure above the king with raised arm grasping
the bridle of the dark horse is derived from

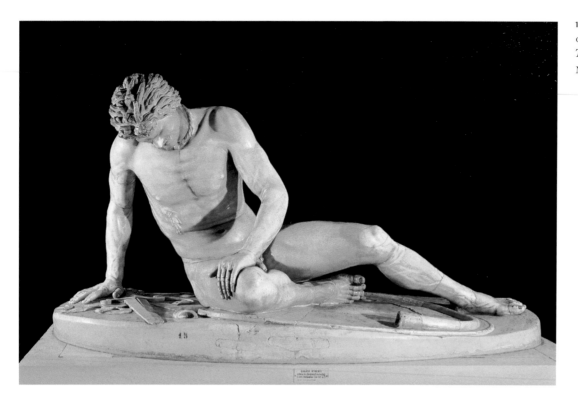

18 the *Borghese Gladiator*; and Colin Fitzgerald's pose is taken from one of the 'horse tamers' on the Monte Cavallo in Rome. But above all, the dynamic structure and rich tonality point to the influence of Peter Paul Rubens. Rubens had made a copy of Leonardo's *Battle of Anghiari* which West is likely to have seen in Paris, but closer to home was the Flemish painter's *Wolf and Fox Hunt* which West certainly saw in the collection at Corsham Court [11]. The rich handling of the surface of the picture also owes much to Rubens, with a feeling for the expressive substance of paint that differs from the smoother handling more typical of neoclassicism.

The painting is structured on two crossed diagonal movements. One of these runs from the line of water and the dogs entering at the bottom left, through the stag's forehead to the line of the highlighted arm that grasps the horse's bridle in the top right quarter of the picture. Other elements, from the light-coloured dog's hindquarters to the spear raised by the figure on the right, parallel this movement. The opposing diagonal takes up Fitzgerald's raised spear, the line of which continues down his left upper arm to link with the king's raised arm, and

continues into the rear leg of the fallen horse at the bottom right. Again, the movement is subtly paralleled in the raised arm of the huntsman at the top centre of the picture. Is this simply a compositional device to give the picture structural coherence, or is it meant to suggest a saltire or St Andrew's cross as a means of reiterating the message that the Mackenzie's family story is part of the national story? It would certainly be an appropriate symbol of the loyalty to the crown that Humberston Mackenzie wished to express, making use of the form that was by this time well embedded in the Union flag.

THE LATER HISTORY OF THE PAINTING

Mackenzie must have intended that the giant canvas should hang in his seat at Brahan. However, this did not happen during his lifetime, for reasons that are not entirely clear. Throughout the 1790s he was engaged on the modernisation of Brahan and this work may have stood in the way of the painting's journey north. Or it may be that it was kept in London so that Francesco Bartolozzi, the king's engraver, could work on the engraving, although this was never to be completed [28]. The painting appears to have

11 | Peter Paul Rubens
(1577–1640) and Workshop
Wolf and Fox Hunt,
c.1615–21

The Metropolitan Museum
of Art, New York, John Stewart
Kennedy Fund, 1910 (10.73)

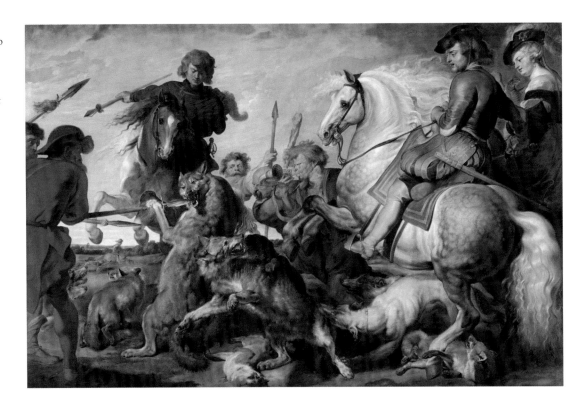

remained in West's studio for more than thirty years, until 1821, when the artist's sons sought permission from the late Lord Seaforth's eldest daughter, Lady Stewart Mackenzie, to include the painting in their father's memorial exhibition – West had died the previous year. The following year the painting was at last shipped north by the London dealers, Woodburn, who supervised the reframing and installation at Brahan.

The painting remained at Brahan until 1952, when the castle was demolished. For safekeeping it was then moved to nearby Fortrose and Rosemarkie Town Hall, where over the years, this great Anglo-American (or, more comprehensively, Britanno-American) painting was seen by only a few visitors. In due course, Lord Seaforth's heirs decided that they had to sell it. It was auctioned in London in 1986 and bought for over half-a-million pounds by the National Gallery of Art in Washington. The story does not quite end there, however, for the British government banned its immediate export. It was then purchased by the National Galleries of Scotland.

Once again the painting travelled north, rolled up as before. Because of its size – it is the largest painting in the National Gallery of Scotland – the canvas had to be re-attached to its supporting stretcher within the Gallery, close to where it would hang. When, eventually, a decision was taken to clean the painting, it was deemed that the painting had suffered enough rolling and unrolling (it had probably spent much of its time in West's studio rolled up) and that the restoration work should be carried out where it hung. This, over many months, was a rare and educative sight for visitors to the Gallery.

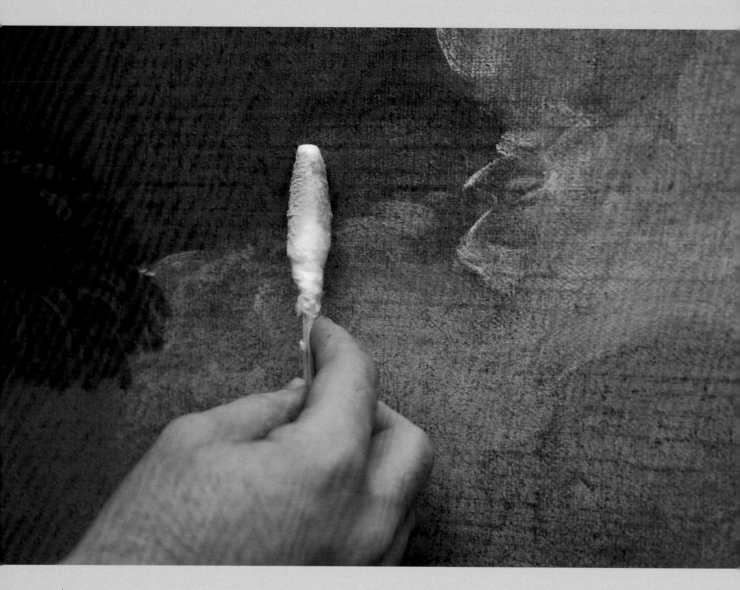

12 | During cleaning: detail of the sky during the removal of the oily layer, which lay directly on the paint surface.

THE ARTIST'S TECHNIQUE
AND THE CONSERVATION OF THE PAINTING

MICHAEL GALLAGHER

THE ARTIST'S TECHNIQUE

Benjamin West painted his vast composition on a single piece of plain-weave linen, some nineteen square metres in area. The fabric was prepared for painting with the application of a thin, off-white coloured ground layer similar to those found in many paintings by the artist. There is little that is consistent in the few contemporary descriptions of West's painting technique, and this perhaps, is a reflection of his predilection for experiment. For example, he is recorded as sketching in his compositions with charcoal and then fixing the outlines with paint. In *The Death of the Stag*, there is evidence that he used a fluid, dark-coloured paint to establish the forms. The dilute oil paint for sketching is likely to have included black, brown and red lead pigment. For example, free marks can be seen under the paint layers in the horse's hindquarters in the lower-right corner of the painting. There are also a number of drip marks in the same area.

West first blocked in the compositional elements, working quite thinly and concentrating on the principal forms. This method allowed the painting to be developed quickly. The important elements were pulled into focus with subsequent applications of colour. This technique accounts for the 'cut-out' quality of some of West's figures. It is an additive process that can leave the protagonists oddly disconnected, creating negative spaces that are sometimes dull and uninspired. This is particularly the case in his large-scale works and might explain why many of his contemporaries expressed a preference for his technically spirited sketches, which visually are more cohesive [14].

In this painting West employs a range of pigments typical of the period, including ochres, umbers and siennas, green earth, vermilion, red lead and Indian red, Prussian blue, black, lead white and transparent lake colours. The predominance of the earth pigments creates a rather gritty texture and an overall warm tonality within which the artist effectively contrasts the rich Prussian blue hues with a variety of strong reds. Although West's fondness for asphaltum as a glazing paint is well documented, there is none of the surface disfigurement that would suggest it has been used to any great extent in this work.

West is also known to have had an enduring interest in the so-called 'secrets' of old master painting techniques. Like many of his

13 | *The Death of the Stag* before conservation began.

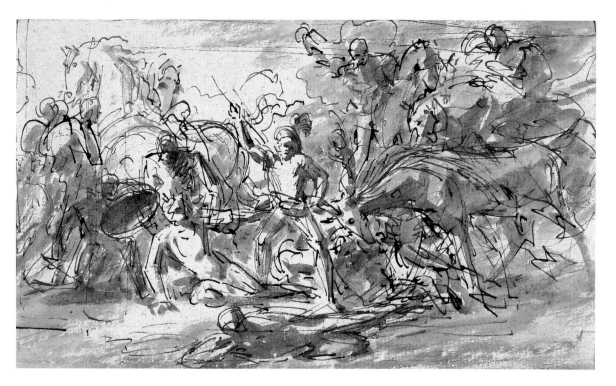

14 | Benjamin West *Study for 'Alexander III of Scotland Rescued from the Fury of a Stag by Colin Fitzgerald'*, c.1784
National Gallery of Scotland, Edinburgh
(D 5620)
Purchased, 2007

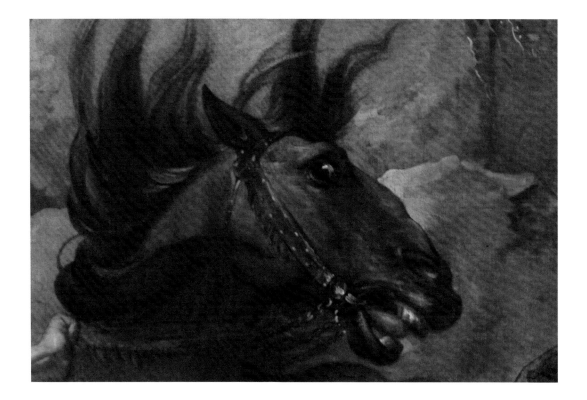

contemporaries, he experimented on occasion with extremely unstable combinations of materials, which he added to his painting medium and some of his later works have suffered as a result. Luckily, although no formal analysis was carried out during the conservation treatment, the condition of the painting, *The Death of the Stag*, suggests that the medium employed here was principally a conventional drying oil with few or no additions. Nevertheless, the painting has changed in appearance. The darker tones of the stag and much of the mid-ground have become more transparent and consequently have lost definition. Additionally, a fine network of drying cracks in these medium-rich areas occasionally reveals paler under layers, creating a thin, slightly impoverished appearance. However, these changes have not undermined the many strengths of the painting. The horses are painted with great vigour, their silvery streaming ringlets revealing West's debt to Rubens and Van Dyck. The head of the rearing chestnut horse [15] is created with a combination of deft wet-in-wet modelling and subsequent glazing, which is exceptionally effective. The treatment of the heads is particularly fine [16, 17], exhibiting a confidence and

directness that West is often accused of lacking. There are weaknesses in some of the figures, particularly the horsemen in the upper part of the composition whose mask-like features suggest an assistant's hand. These, however, are the exception.

The features of Colin Fitzgerald and Alexander III illustrate wonderfully comments made by the painter Gilbert Stuart about West's technique for rendering flesh tones. Stuart worked for a time in West's studio and, when asked for his opinion on the progress of a portrait that was being worked on by another studio assistant, John Trumbell, he commented: 'Pretty well, pretty well, but more like our master's flesh than nature's. When Benny teaches the boys, he says "Yellow and white there", and he makes a streak, "red and white there", another streak, "blue – black and white there", another streak, "brown and red there, for a warm shadow", another streak, "red and yellow there", another streak.'

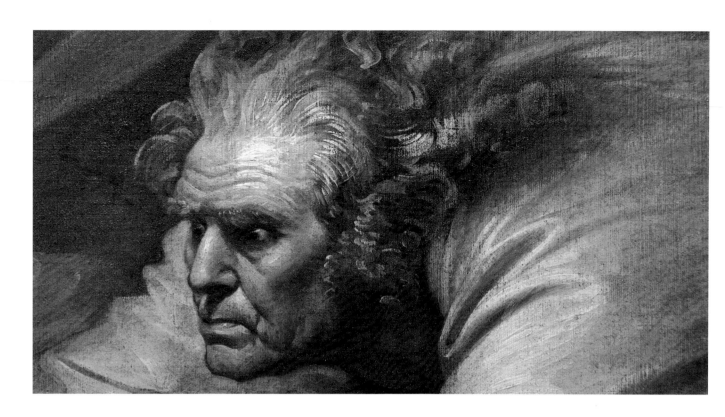

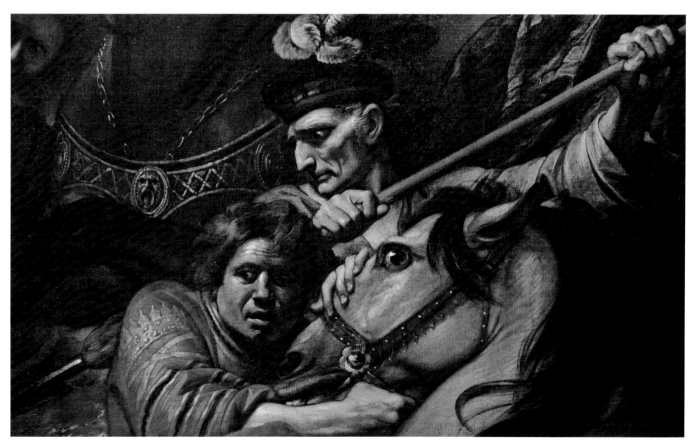

16 | After restoration: West's treatment of the heads of the figures in the painting is particularly fine.

17 | After restoration: the figures exhibit a confidence and directness that the artist's work is often accused of lacking.

THE CONDITION OF THE PAINTING

The decision to proceed with full conservation of the painting was taken in 2004, although the sheer size of the work made it a daunting prospect for the conservator involved. It was clear that embarking on the restoration project in the conservation studio, which was located a mile away in the Scottish National Gallery of Modern Art, would put the painting through another hazardous sequence of rolling and unrolling. It was, therefore, decided to carry out the work while the painting remained on display in the National Gallery of Scotland, thereby providing visitors with the opportunity of witnessing a major conservation process at first hand.

Close examination showed that for a work of its age and size the painting remained in very good condition. Surprisingly, it had never been lined – a process of adhering a new canvas to the back of the original one to give it extra strength. In this case there were no significant signs of the artist's canvas degrading to a point where this process needed to take place. Although it was clear that the work had been restored at least once in the past, the ground (the preparatory layer

covering the entire canvas that plays a crucial role in the tonal balance) and paint layers were also in good condition. West's thickly loaded brush-strokes, describing the texture of fur, the swirl of draperies, the movement of muscle and sinew and the metallic sheen of the armour and weaponry, are well preserved and create a wonderful variety of texture in the paint surface which is unlikely to have withstood the lining processes that were once used.

However, some changes were evident, including paint losses around old tears and punctures in the canvas. A number of these extended over several centimetres and had been clumsily filled and retouched, and their appearance was too glossy. There were more wide-spread, smaller paint losses at the edges of the crack pattern seen across the surface of the paint layer. It was also anticipated that there might be some wear to the vulnerable darker-coloured passages, something difficult to judge under a discoloured varnish.

When the picture arrived in Edinburgh in 1987, a varnish was applied in an attempt to refresh its rather 'tired' appearance. It was known that a layer of surface grime had been removed and a

18 | Before cleaning: the sky and rocks were covered in a varnish that was extremely yellow and so oxidised that the surface had become matt and scaly.

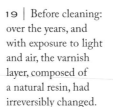

19 | Before cleaning: over the years, and with exposure to light and air, the varnish layer, composed of a natural resin, had irreversibly changed.

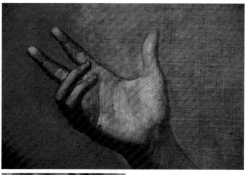

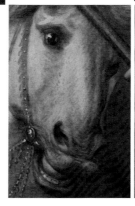

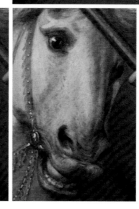

20 | Detail of the head of the white horse before and after conservation.

26 layer of varnish applied in the 1970s while it was on display in Fortrose and Rosemarkie Town Hall. However, the very discoloured varnish that deadened the picture was considerably older – dating possibly from the end of the nineteenth or the beginning of the twentieth century.

Over the years, and with exposure to light and air, this layer, composed of a natural resin, had irreversibly changed. What had once been a glossy, clear layer, which brilliantly saturated the artist's choice of colours and paint textures, had changed to a semi-opaque, yellowed and acidic coating [19]. Inevitably, this caused a drastic change to the colour and tonal relationships within the picture: whites looked muddied, blues appeared greener and purples took on a flat, greyish hue. A varnish that has aged acts like a milky, diffusing layer that darkens the light tones, while simultaneously robbing the dark tones of depth and saturation. Consequently, the dramatic movement that West had sought to create was reduced to a frieze of undifferentiated figures.

VARNISH REMOVAL AND CLEANING

The effect of varnish removal can be seen most tellingly in a comparison of the horse's head at the far left of the composition before and after this process. The previously rather flat and disturbingly jaundiced animal now has a lively and subtly modelled head [20]. Not only are the cooler slate grey tones easier to see, but the warm colour flecks that so enliven the muzzle now have all the impact that the artist intended.

It should be noted, however, that discoloured varnish [18] was not the only factor responsible for the rather dead and leaden quality of the painting. Repainting by previous restorers was also an issue, and its removal proceeded at the same time. In the area of sky at the top left corner of the composition a heavy, milky, turquoise coloured paint had been applied over both losses and staining in the original paint layer. Fortunately, this layer, probably applied over a century ago and covering the entire sky, was readily soluble along with the varnish. The effect of the overpainting of the sky is illustrated by a comparison before and after cleaning of the area around the basket hilt of the sword gripped

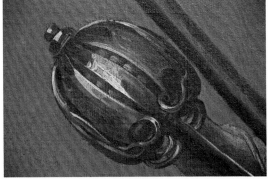

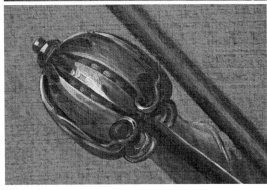

by the horseman at the top left [21]. This shows that the overpainting had been brushed up to the contours with a loss both of the subtlety and the gentle vibrancy of the sky that the artist had intended.

The principal reason for the radical over-painting of the sky seems to have been the presence of a thin, markedly discoloured oily coating on the original paint surface. The reason for the application of this oily coating [12] is not entirely clear. 'Oiling out' was a popular practice in the late eighteenth and nineteenth century when oil was rubbed locally into the surface to revive colours that had sunk or become matt during the drying process. However, the layer on this painting appears to have been applied at a later stage.

The explanation may be related to the blanch-ing evident in the general haziness of the dark tones after the removal of varnish. This whitened effect was also due to the development of fine cracks within the structure of the paint. Blanching [22] is often caused by excessive moisture (rather like the white ring caused by a wet glass left on a varnished table), and it is possible that the thin layer of oil was an attempt to combat widespread

blanching brought about by the exposure of the painting to high levels of humidity when it was shipped north to Brahan Castle in 1822.

However, there is another possible explanation for this oily layer, which is due to the actions of West himself. Joseph Farington, diarist and fellow artist, recorded in July 1806 that West cleaned two of his pictures from the 1770s, which were owned by Lord Grosvenor. He noted that West 'washed them and then passed oil over them, part of which was absorbed in the night and the next day he rubbed off what was on the surface, the picture appeared like a diamond'. Whatever the cause, a judicious choice of organic solvents was used to carefully thin this oily layer so that it became less visible.

Cleaning also revealed areas of old paint loss. There were many pinhead losses, the result of the frequent rolling and unrolling of the canvas. There was a good deal of paint abrasion [23] – the disruption of the vulnerable dark tones caused by injudicious cleaning in the past. In addition there was a complex tear running through the sleeve of Alexander III's red tunic [24]. The tear, straightforward to restore in comparison to paint abrasion, is likely to have occurred between 1952

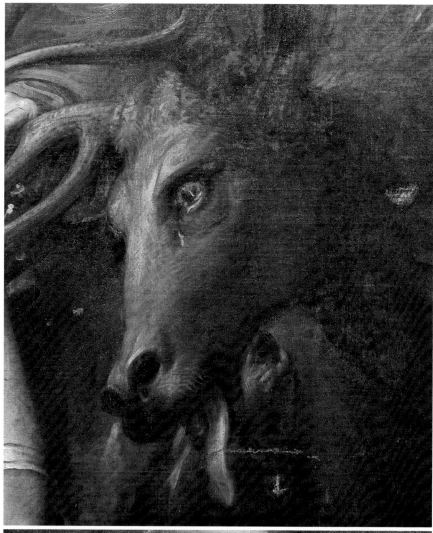

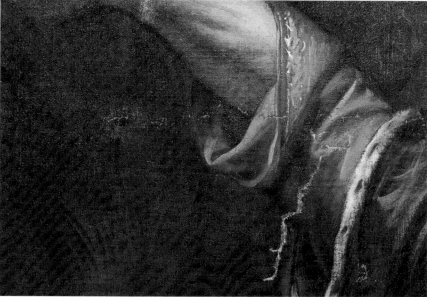

23 | After cleaning: the most disturbing aspect of this detail of the stag is the general disruption of the dark tones caused by injudicious cleaning in the past.

24 | The repaired tear in the canvas of the painting support is shown clearly after cleaning.

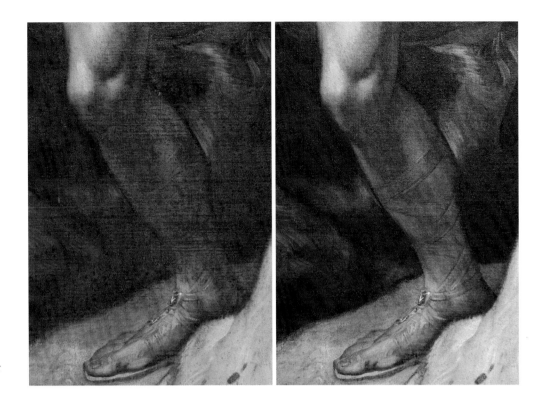

25 | Colin Fitzgerald's right leg before and after conservation.

when the painting was taken to Fortrose and Rosemarkie Town Hall and 1972 when it was surface cleaned and revarnished. In these years the hall had been used on occasion as a badminton court!

Cleaning revealed another peculiar phenomenon – a pronounced pattern of darkening of the paint layer that follows the weave of the canvas [25], particularly the horizontal direction of the weave. This coincides with the warp or fixed weaving threads. It is more obvious in thinly painted, dark toned areas and can be seen, for example, running through the shadowed throat of the principal protagonist, Colin Fitzgerald.

The irregular pattern of darkened threads may also be related to the fact that oil paint becomes increasingly transparent with age. The reason this phenomenon is more pronounced along the horizontal threads could be due to the warp threads being treated with various substances such as palm oil or tallow to make them less susceptible to friction during the weaving process. This was a well-known practice in the later nineteenth century.

As already mentioned, West's canvas is unlined and this has left visible on the reverse a coating of what appears to be red lead. This was probably applied early in the life of the painting, either when it was in West's studio or possibly after its journey to Scotland as a means of discouraging mould growth or insect activity. Given the size of the canvas, its application would have involved a considerable amount of binding medium or thinners which would have soaked into the fabric, making it very dark. The thin off-white coloured ground layer of the painting is composed principally of lead white pigment and its increasing transparency when taken in combination with a darkened fabric support would contribute to this perceived darkening of the paint layer.

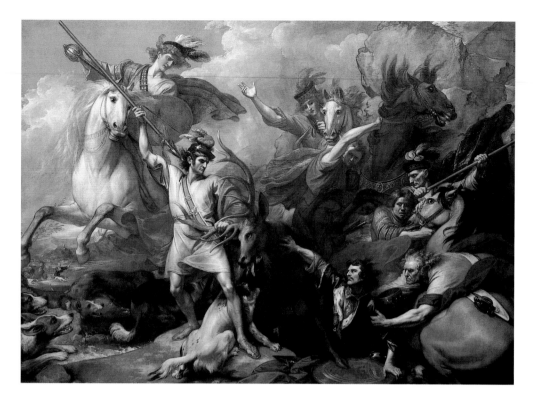

30 RESTORATION

Following the removal of the discoloured varnish and later overpainting, as well as the reduction of the oily coating already mentioned, the painting was given several thin layers of fresh varnish to saturate the surface and to isolate the original paint layer from the restoration that would follow [26]. The retouching phase involves the careful reintegration of losses and abrasion with the original paint surface. The governing principles for this process are that the materials used for retouching should be both stable and easily reversible in the future. By dealing in a focused way with the small losses caused by abrasion, relatively little retouching is required. Nonetheless, the impact of this minimal intervention can be significant. This is well illustrated

27 | A hound's paw and drapery after varnish removal and after restoration.

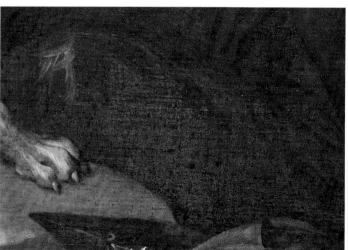

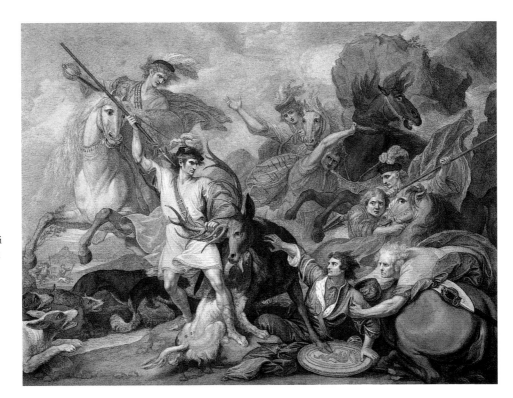

28 | Francesco Bartolozzi
(1727–1815); after Benjamin
West
*Alexander III of Scotland
Rescued from the Fury of a
Stag by the Intrepidity of
Colin Fitzgerald*, 1788

National Gallery of Scotland,
Edinburgh (P3105) Purchased
by the Friends of the National
Galleries of Scotland, 2005

in the drapery where the severely rubbed folds
[27] were retouched, but it was considered
inappropriate to reconstruct the missing or worn
plaid evident in some of the more compromised
areas of drapery, for example the cloak worn by
the horseman in the upper left of the picture.
Similarly, the hindquarters of the hound were
glazed to combat the disruptive effects of the
blanching and to recover a sense of logic in the
spatial relationships within the group.

The most disturbing effects of the darkened
and abraded threads throughout the painting were
also tackled. This was the most challenging part
of the restoration as it was necessary to find an
acceptable balance between suppressing an effect
that undermined West's intentions while avoiding
clogging the surface with excessive restoration. By
carefully retouching the dark, horizontal staining
in Colin Fitzgerald's throat, the original brush-
work suddenly takes precedence and it becomes
possible to register the hatched marks West used
to describe and animate the form.

However, one problem area of the painting
did demand a slightly more creative approach at
the retouching stage. The right leg of the central
rearing chestnut horse ends abruptly –

it appears to be missing a hoof! Fortunately,
the contemporary engraving by Bartolozzi [28]
shows that this disturbing anomaly has always
been present. It may simply have been a detail
that was forgotten – though would George III
not have spotted it when he praised the action
of the horses? At any rate, the problem remained
that, free of discoloured varnish, a horse leg minus
a hoof appeared incongruous. Following lengthy
discussions with conservation and curatorial
colleagues, a compromise was reached: existing
folds in the background drapery were slightly
extended and reinforced so that the viewer's
attention would not immediately be drawn to this
curious detail. But compromises of this sort are
systemic to a conservation project of this com-
plexity: a complexity laid-bare when working on
this enormous painting in public.

Published by the Trustees of the
National Galleries of Scotland, Edinburgh 2009

Text © the Trustees of the National Galleries of Scotland

ISBN 978 1 906270 12 4

Designed and typeset in Adobe Caslon by Dalrymple
Printed on Hello Matt 150gsm by Nicholson & Bass Ltd,
Newtownabbey, Northern Ireland

All photography by Antonia Reeve © the Trustees of the
National Galleries of Scotland except for the following images:
8 © National Portrait Gallery, London; 11 © The Metropolitan
Museum of Art, New York; 10 Bridgeman Art Library.

Cover images: details from Benjamin West *Alexander III of
Scotland Rescued from the Fury of a Stag by the Intrepidity of Colin
Fitzgerald (The Death of the Stag)*, 1786, National Gallery of
Scotland, Edinburgh

Frontispiece: a comparision of Colin Fitzgerald's head and neck
before (left) and after restoration. By carefully retouching the
dark horizontal staining, the original brushwork suddenly takes
precedence.

The proceeds from the sale of this book go towards supporting
the National Galleries of Scotland. For a complete list of current
publications, please write to: NGS Publishing at the Scottish
National Gallery of Modern Art, 75 Belford Road, Edinburgh
EH4 3DR or visit our website:www.nationalgalleries.org

*National Galleries of Scotland is a charity registered in Scotland
(No.SC003728)*